PARIS
STREET
STYLE

All rights reserved.
Published in the United States by Clarkson Potter/
Publishers, an imprint of the Crown Publishing Group,
a division of Penguin Random House LLC, New York.
www.crownpublishing.com
www.clarksonpotter.com

CLARKSON POTTER is a trademark and POTTER
with colophon is a registered trademark of Penguin
Random House LLC.

Originally published in France by Hachette Livre
(Marabout) in 2015.

ISBN 978-1-101-90738-2

Printed in China

Cover design by Danielle Deschenes
Cover illustration by Zoé de las Cases

10 9 8 7 6 5 4 3 2 1

First US Edition

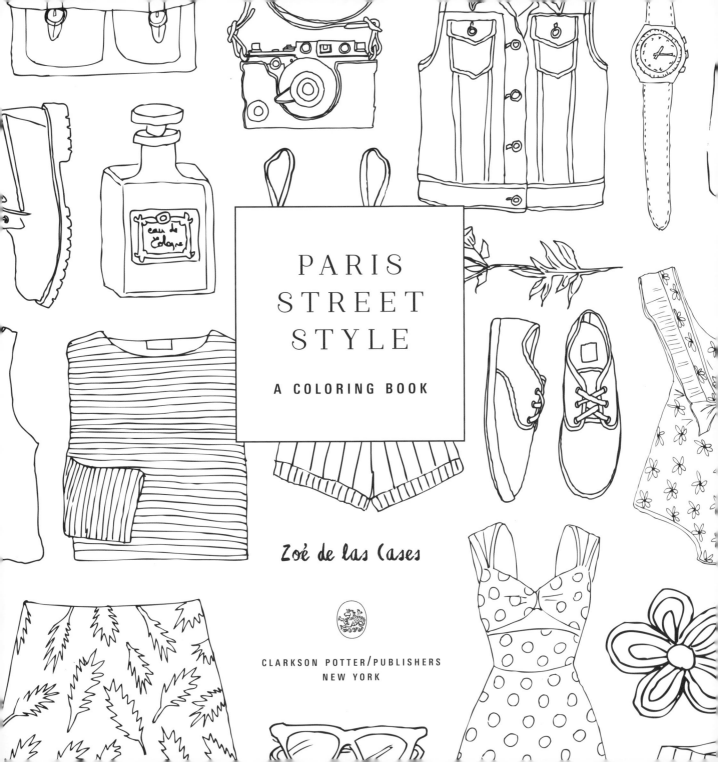

PARIS
STREET
STYLE

A COLORING BOOK

Zoé de las Cases

CLARKSON POTTER/PUBLISHERS
NEW YORK

This book belongs to:

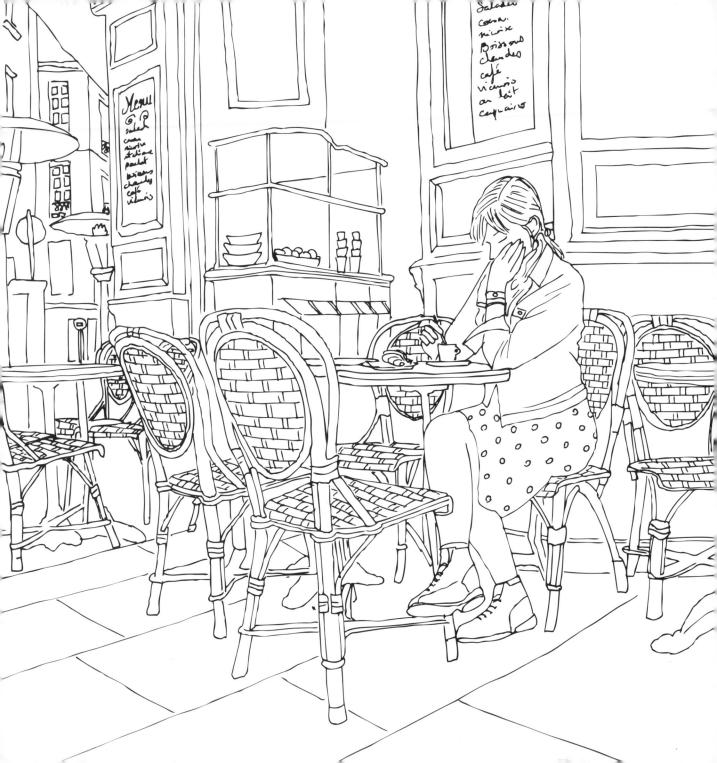

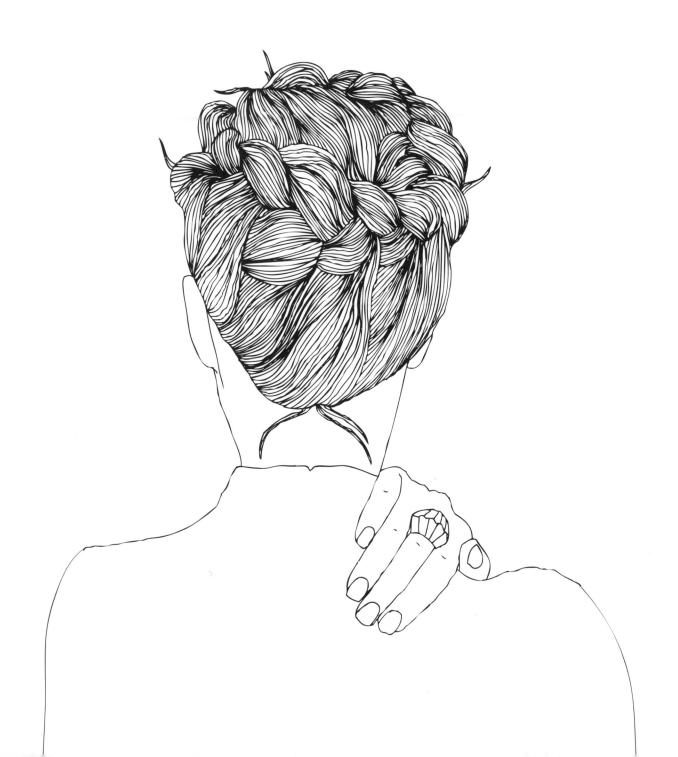

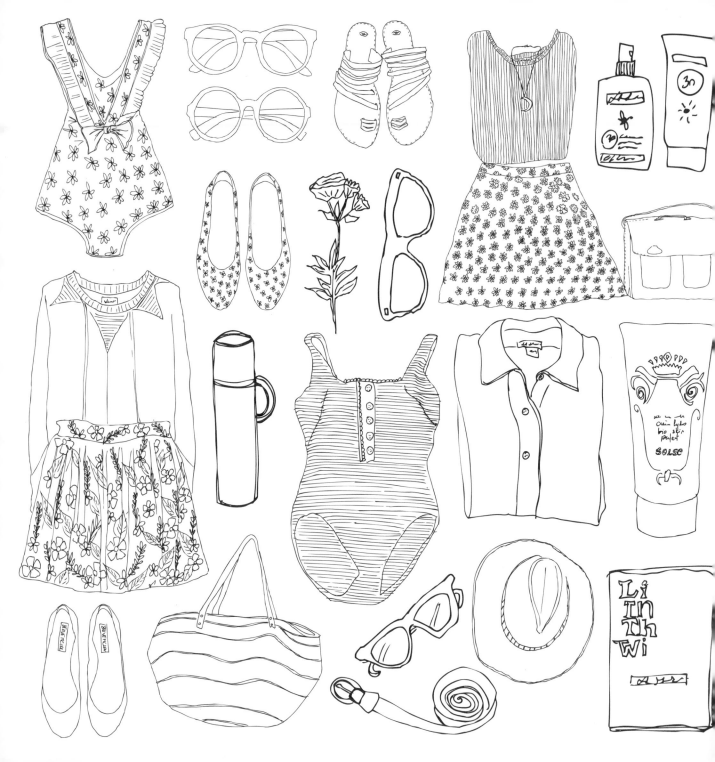

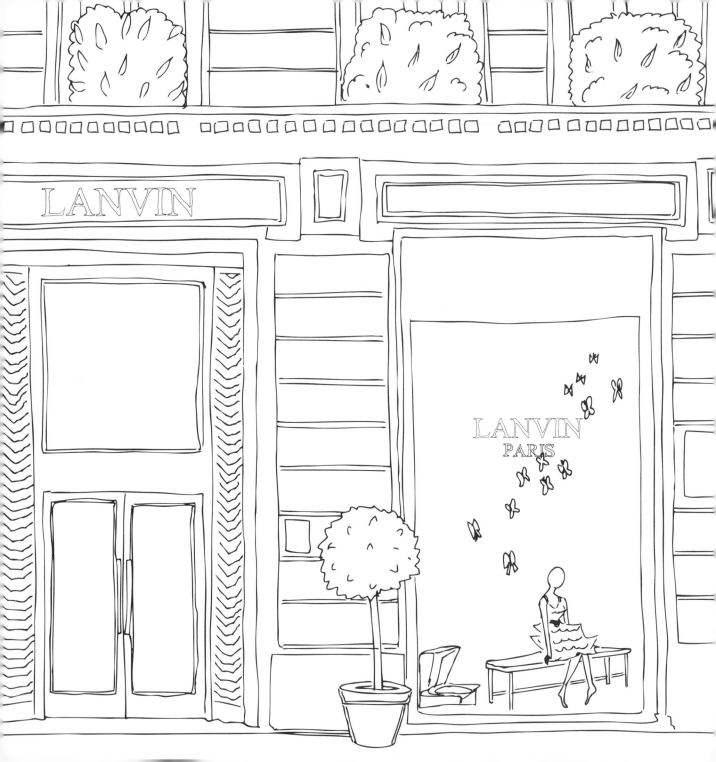

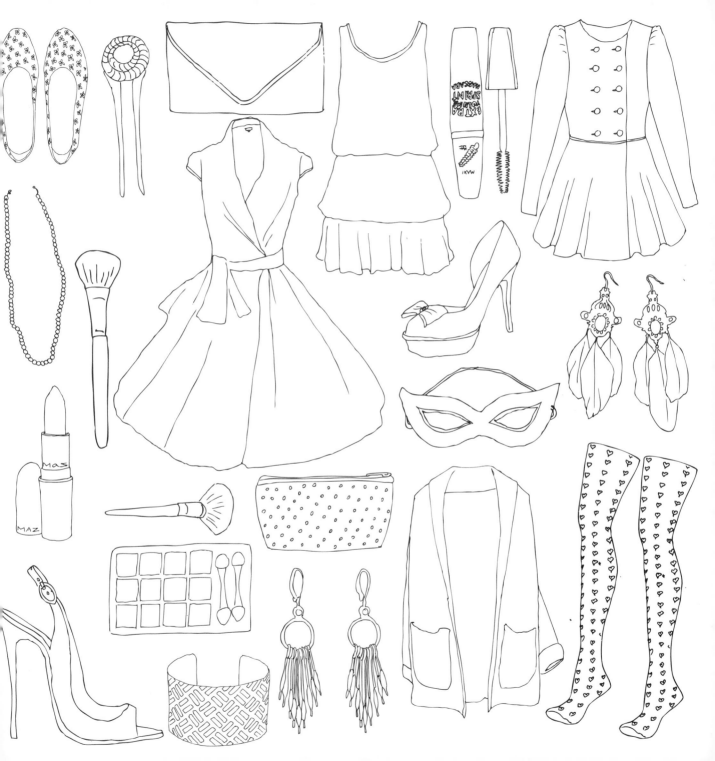

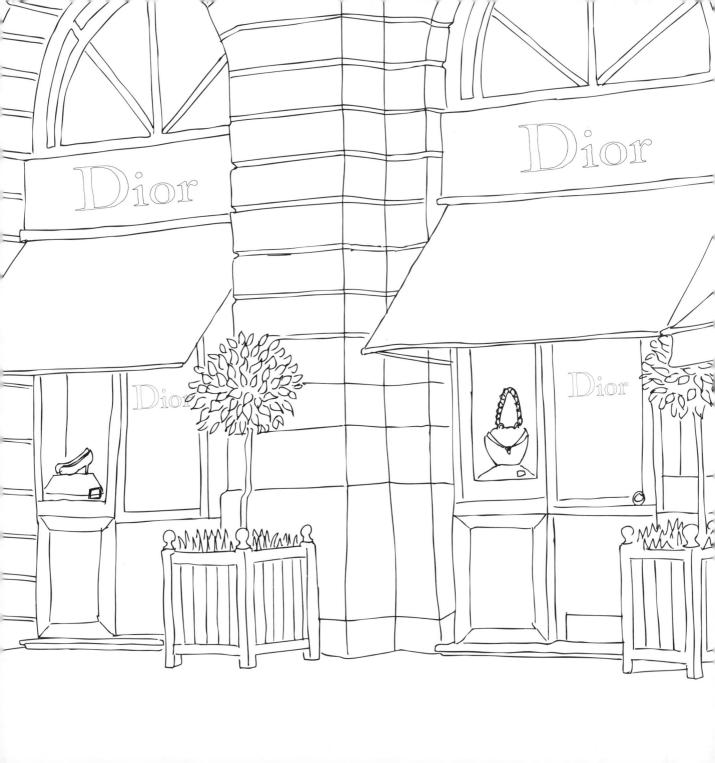

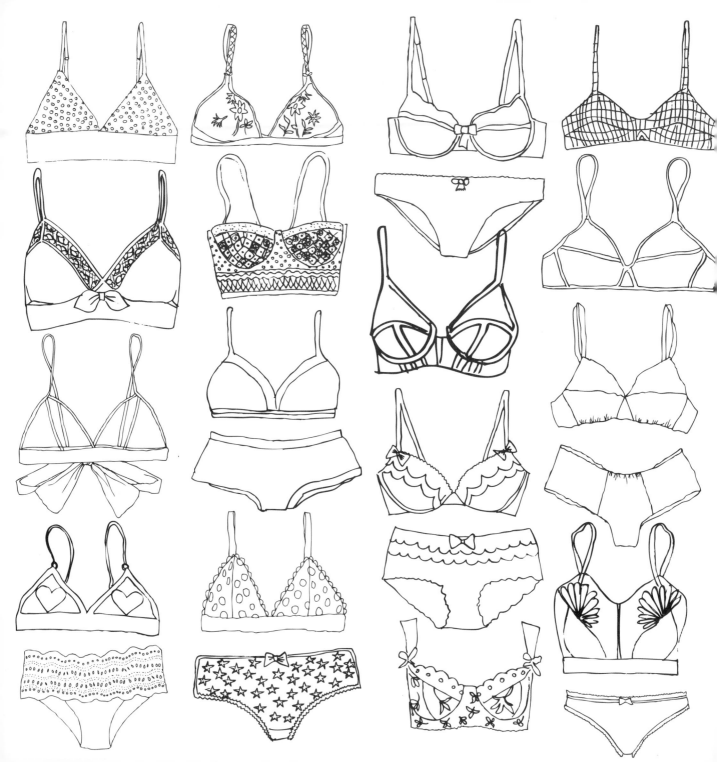

l'été indien

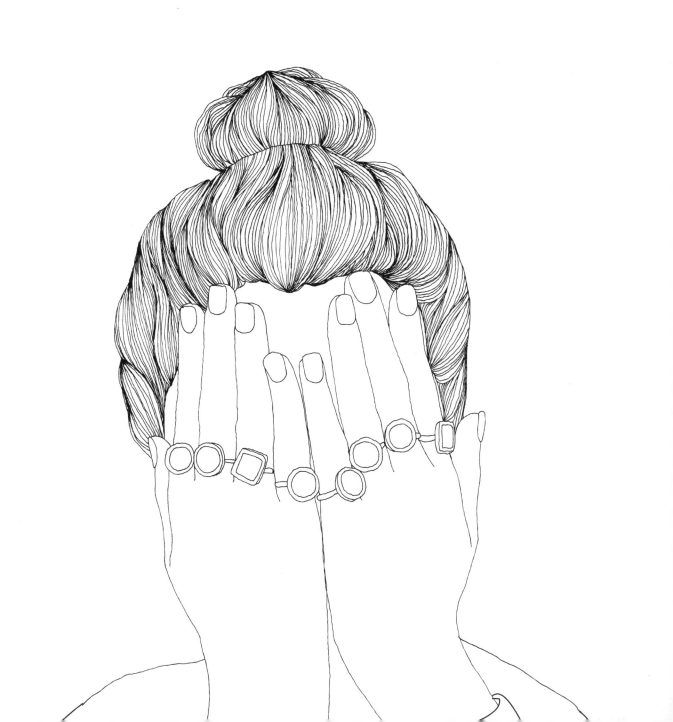

bonne nuit

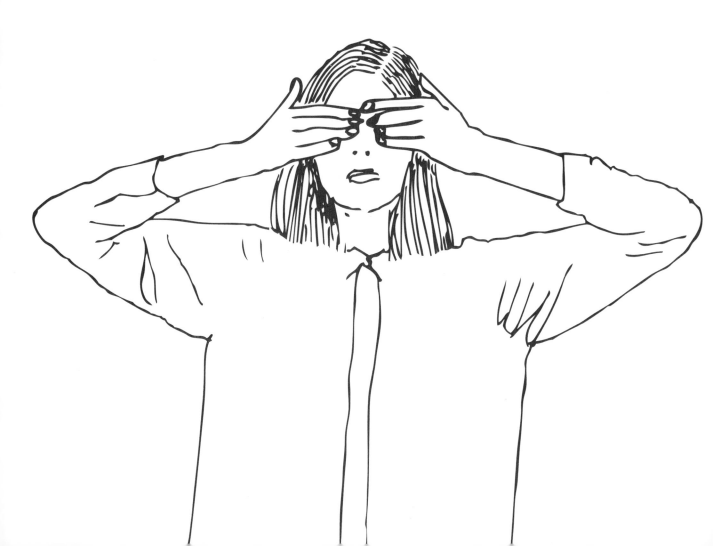

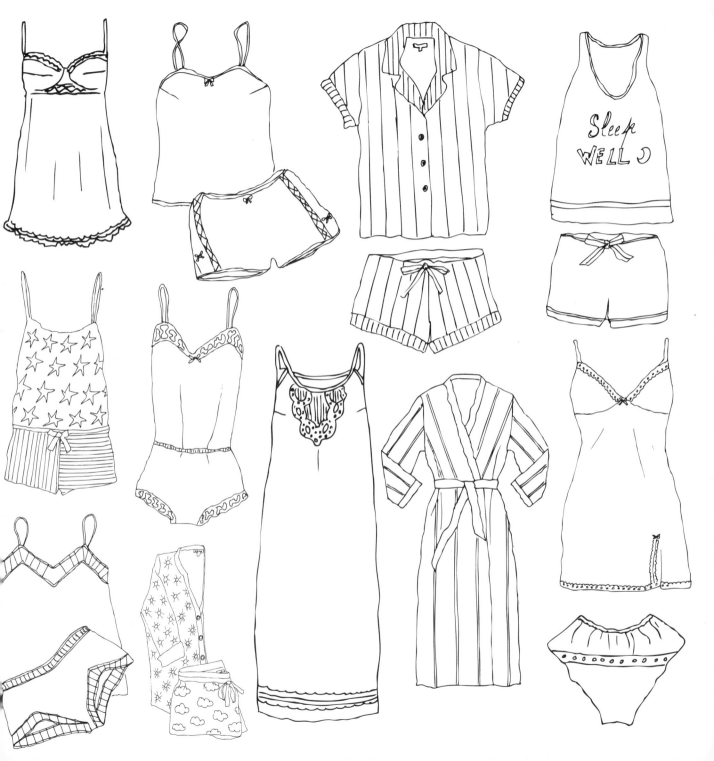

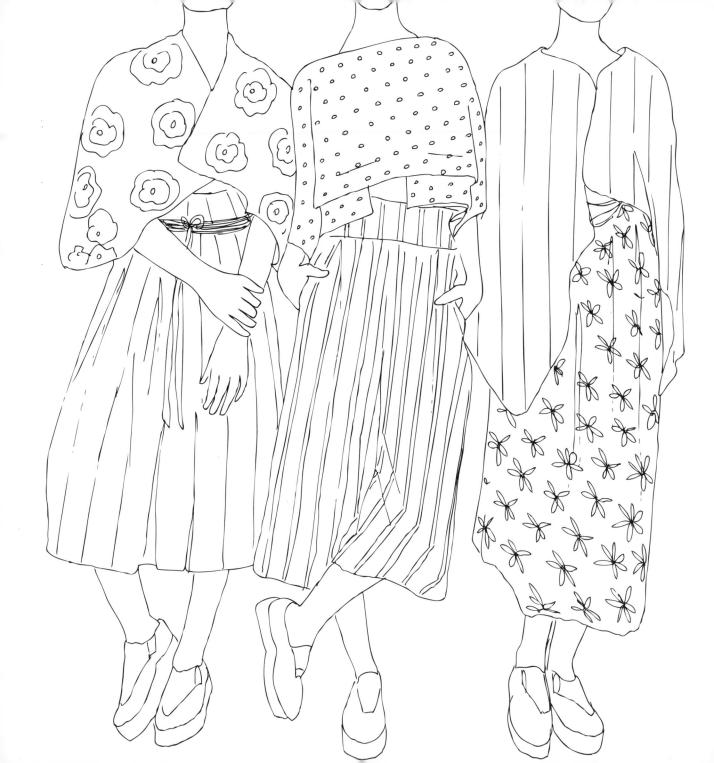

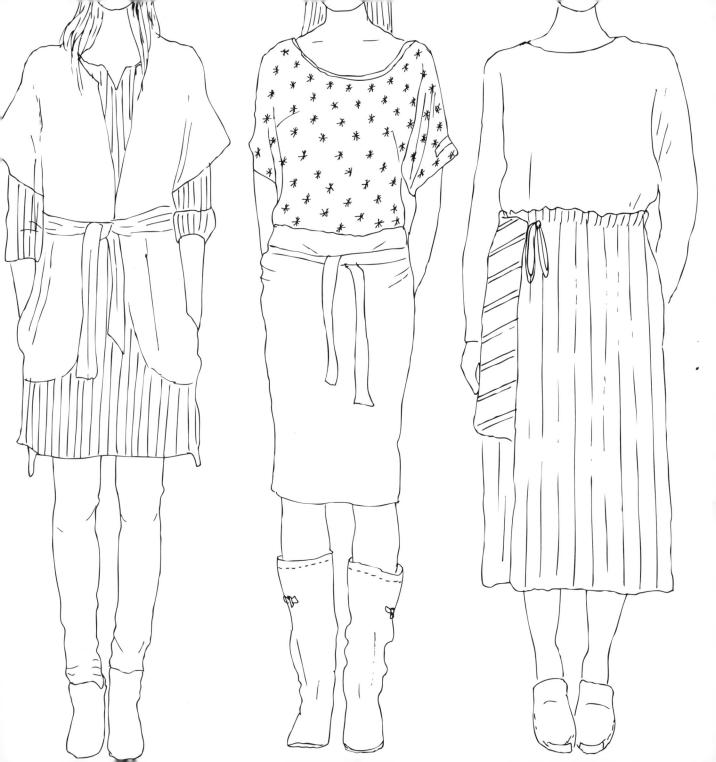

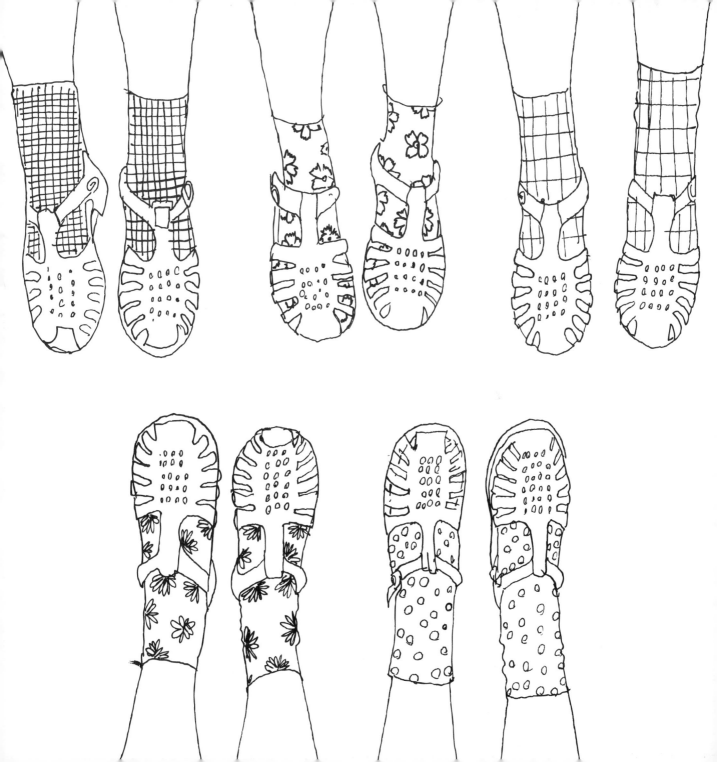

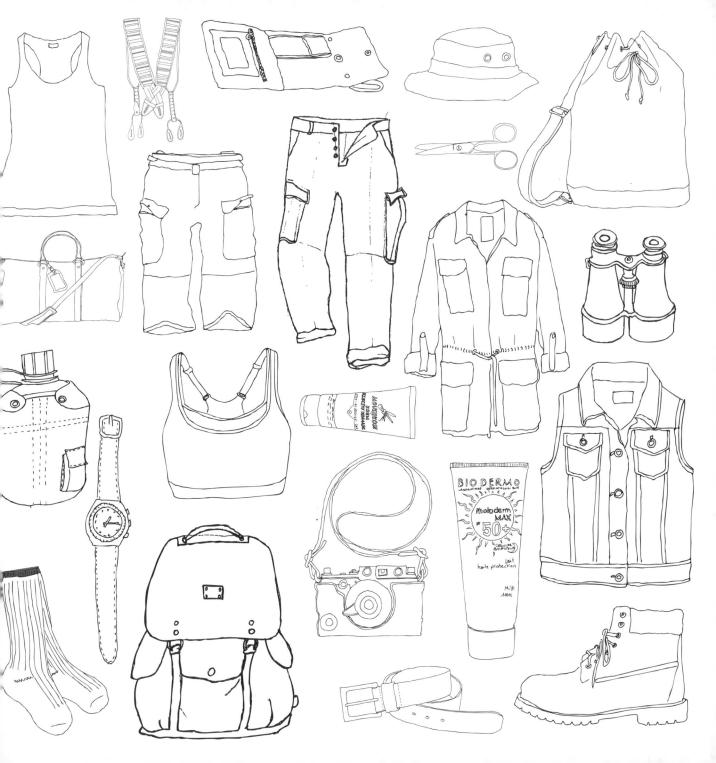

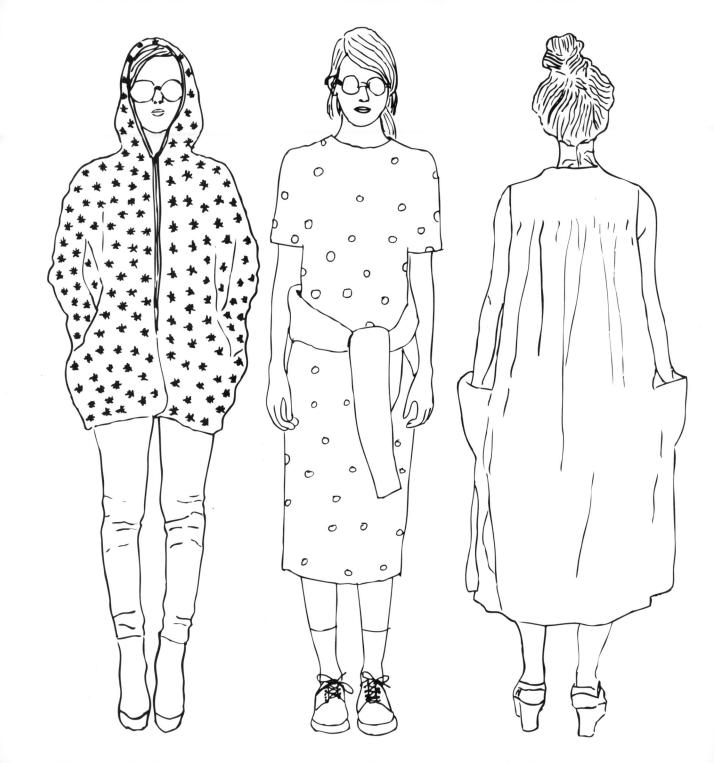

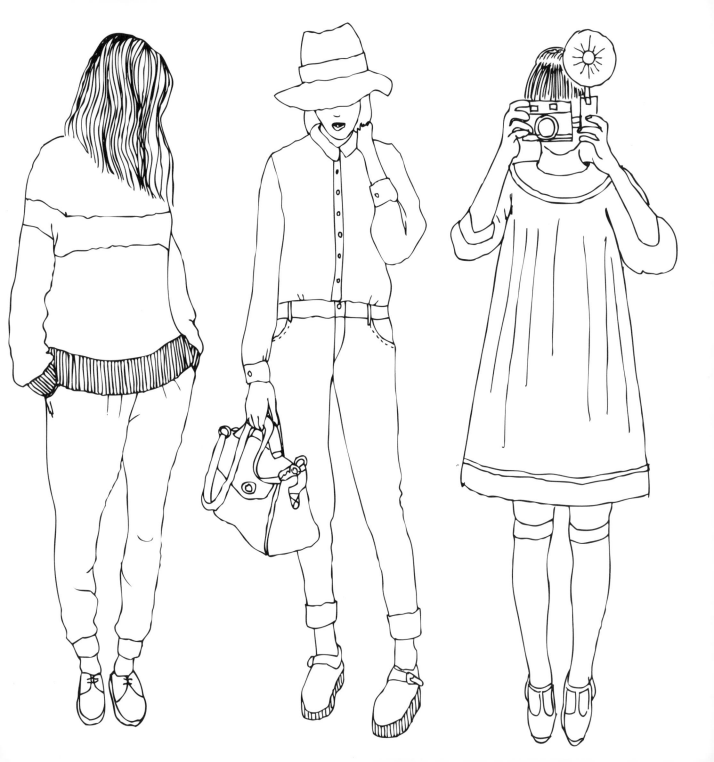

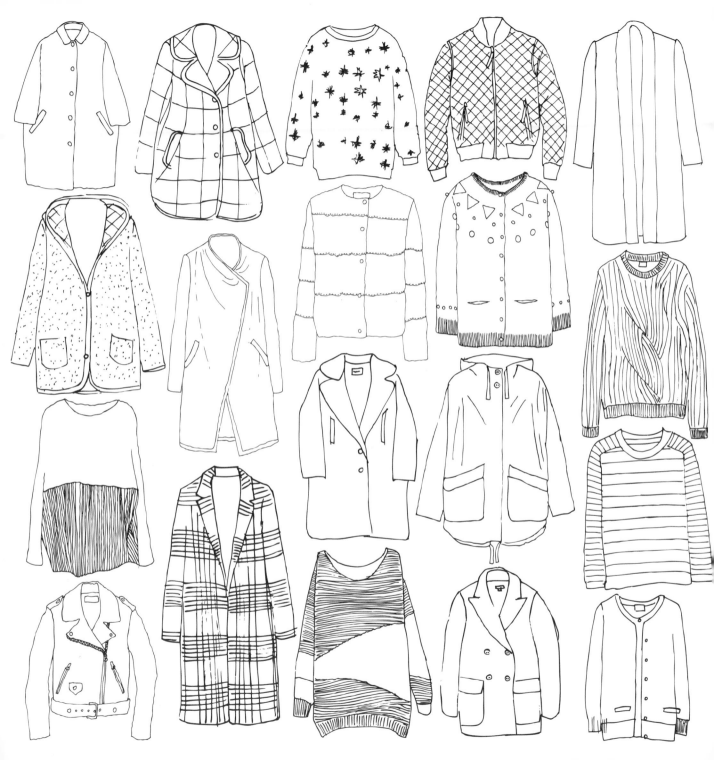

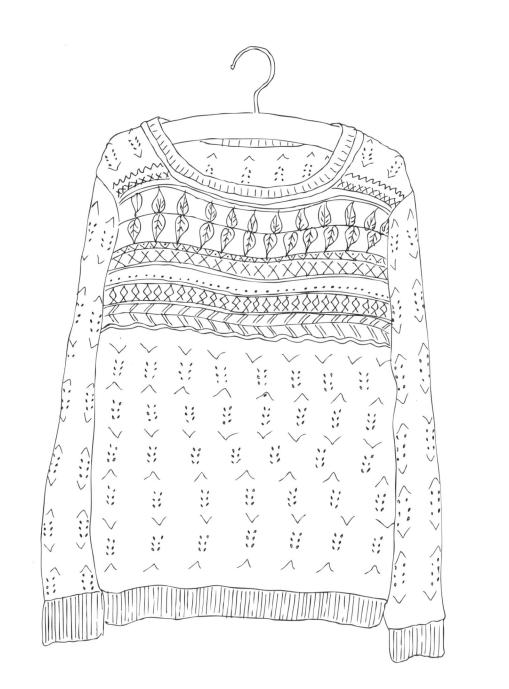

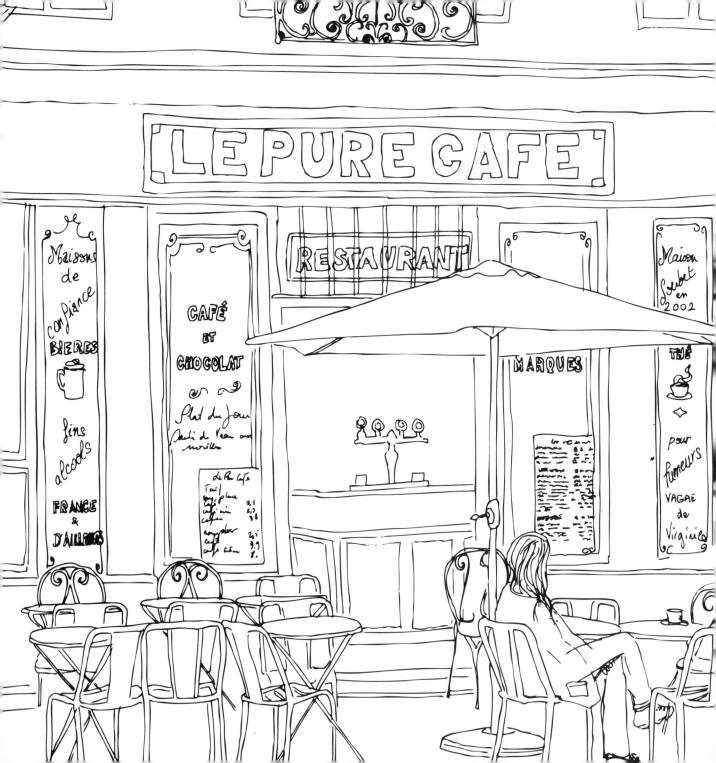

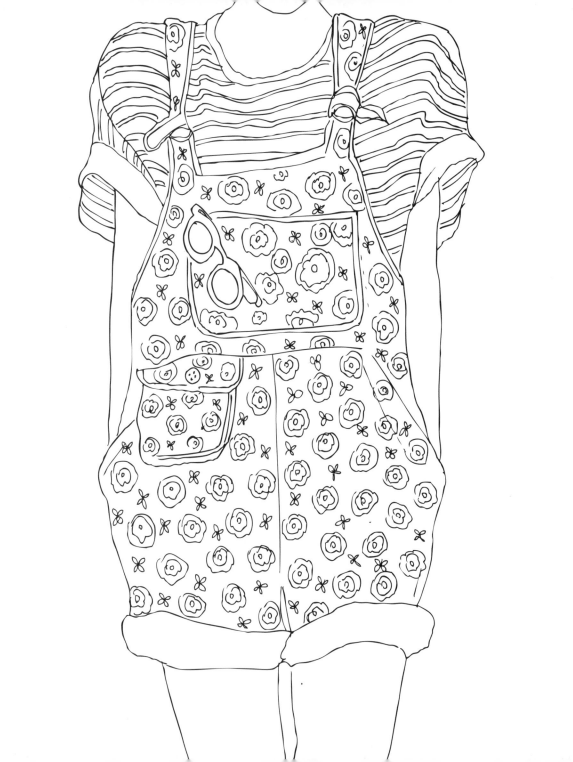

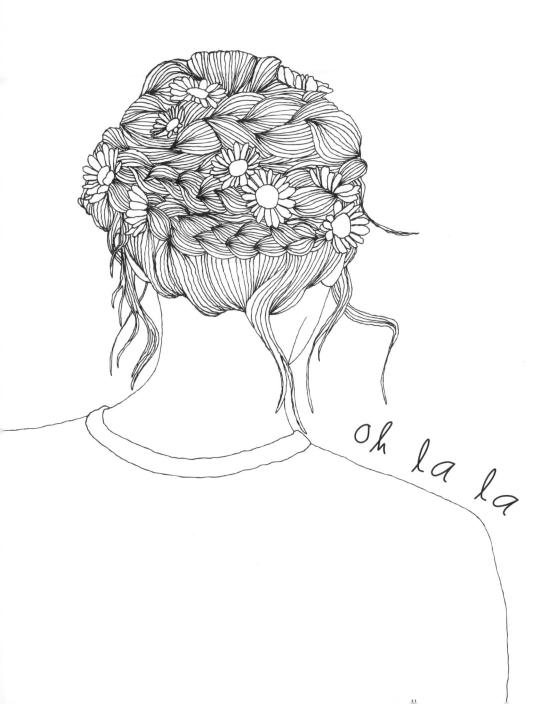

oh la la

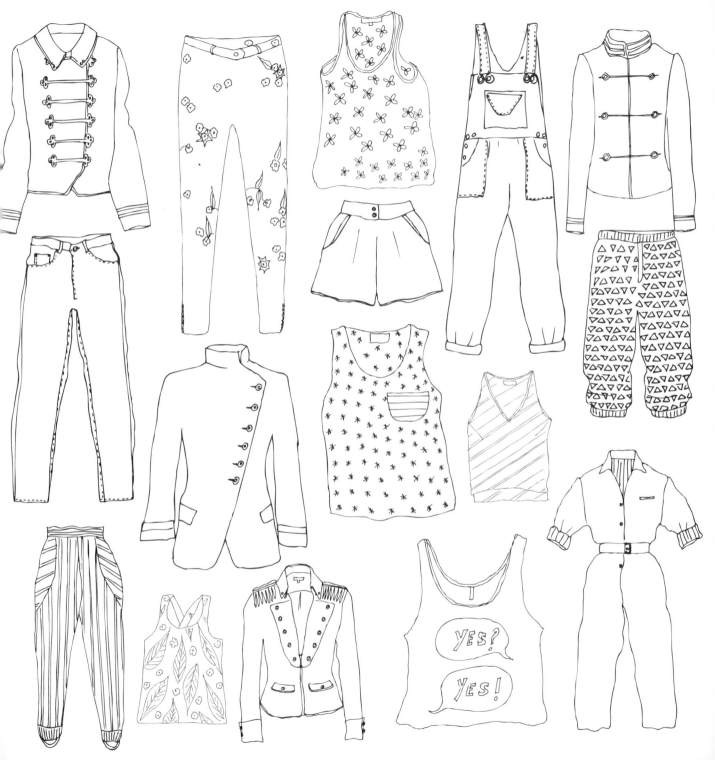

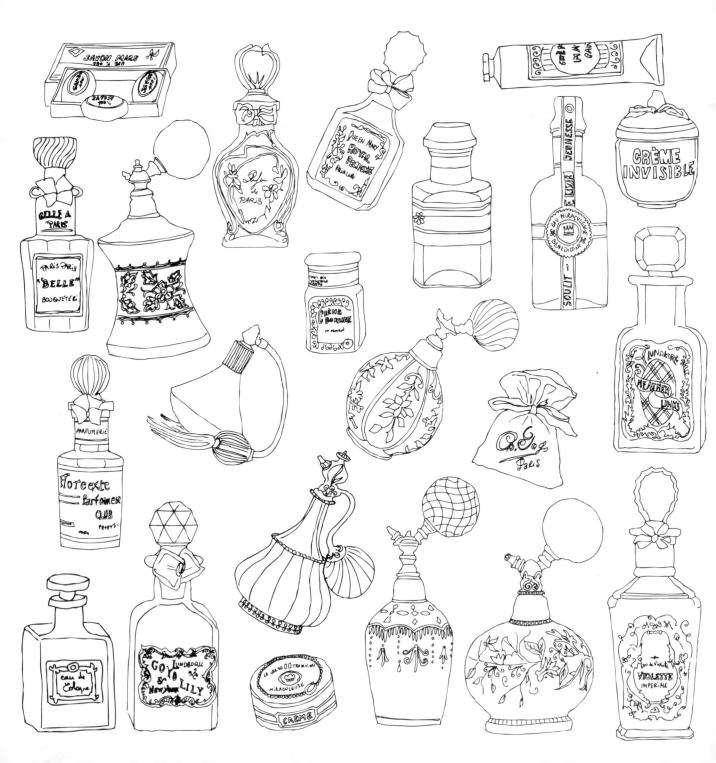

Paris sera toujours paris

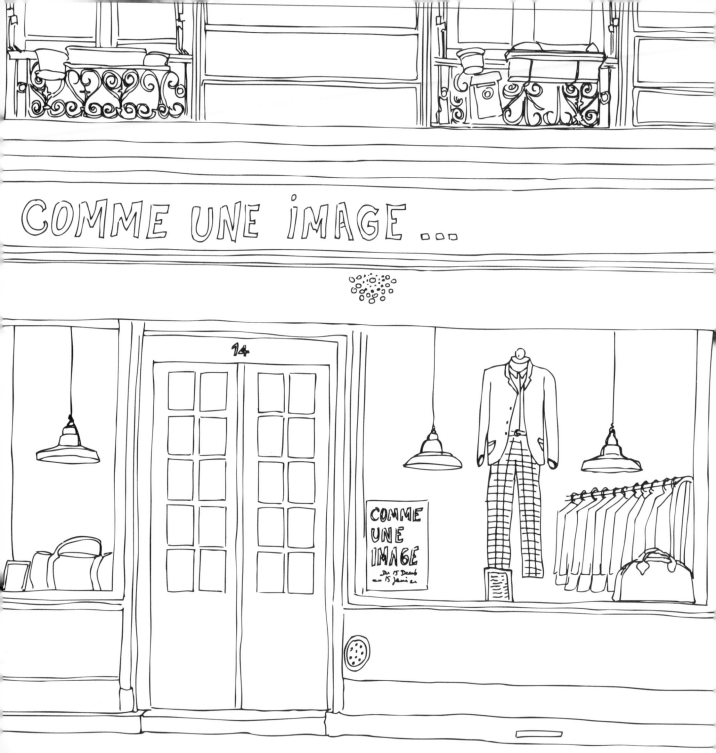

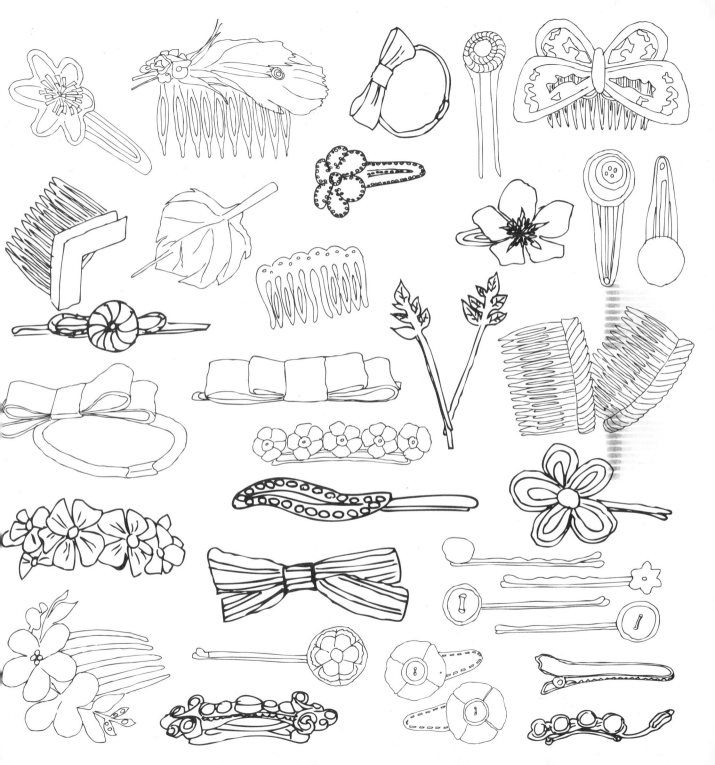

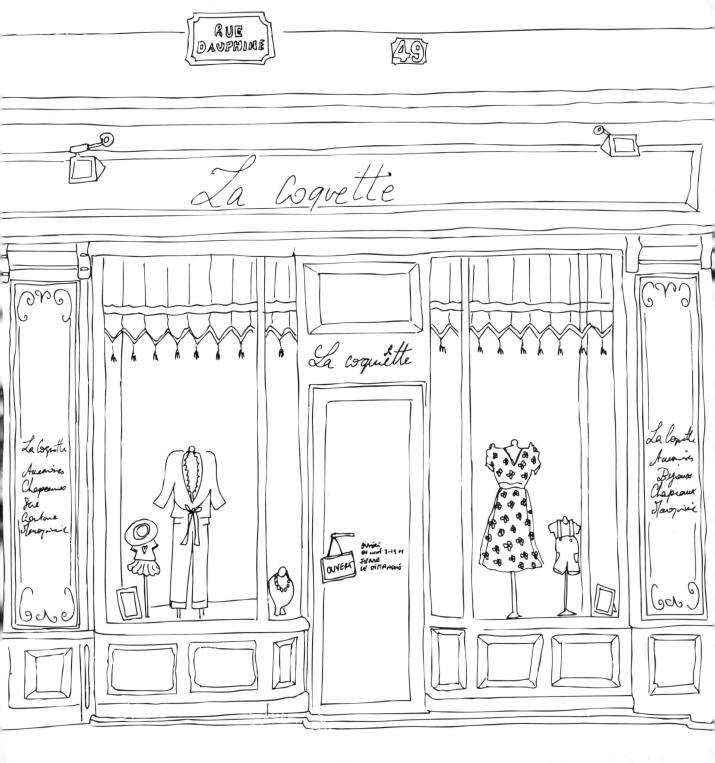

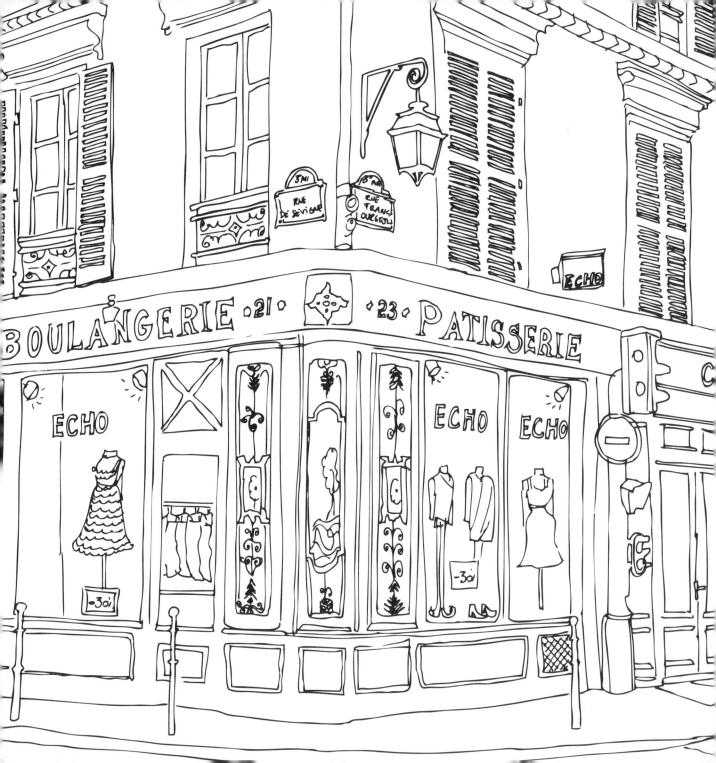

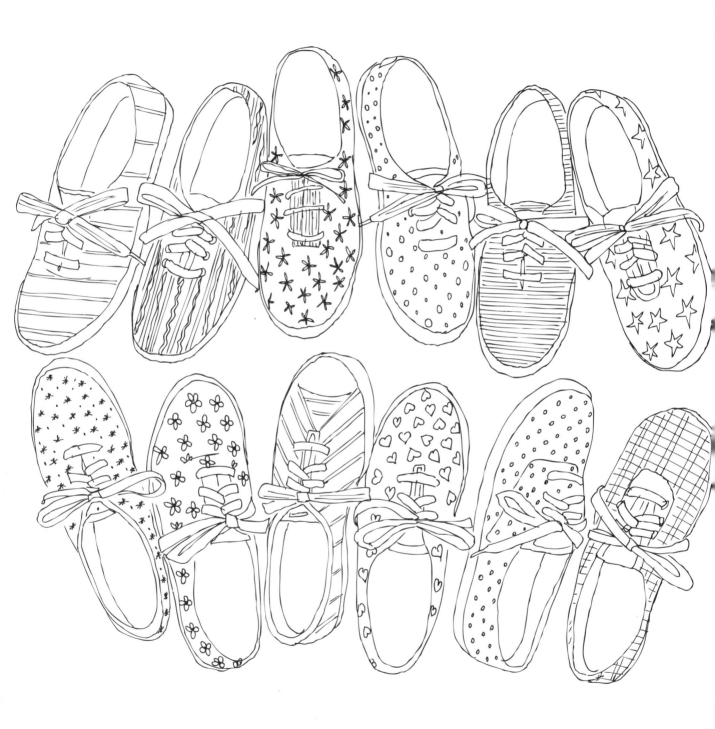

la vie en couleurs

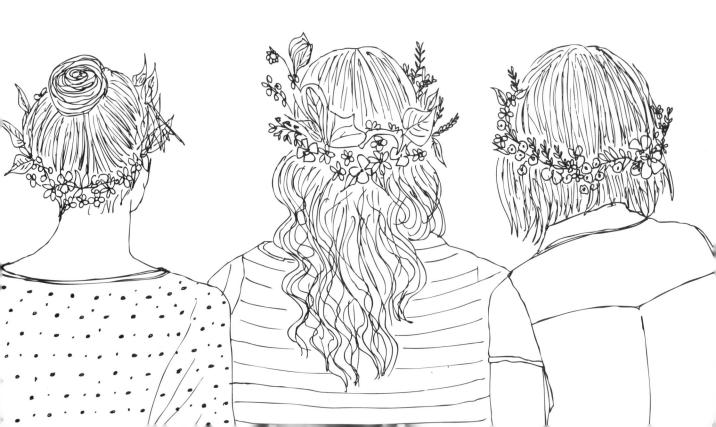

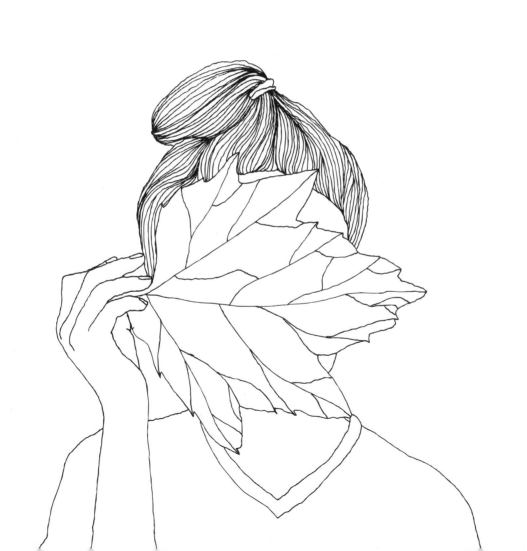

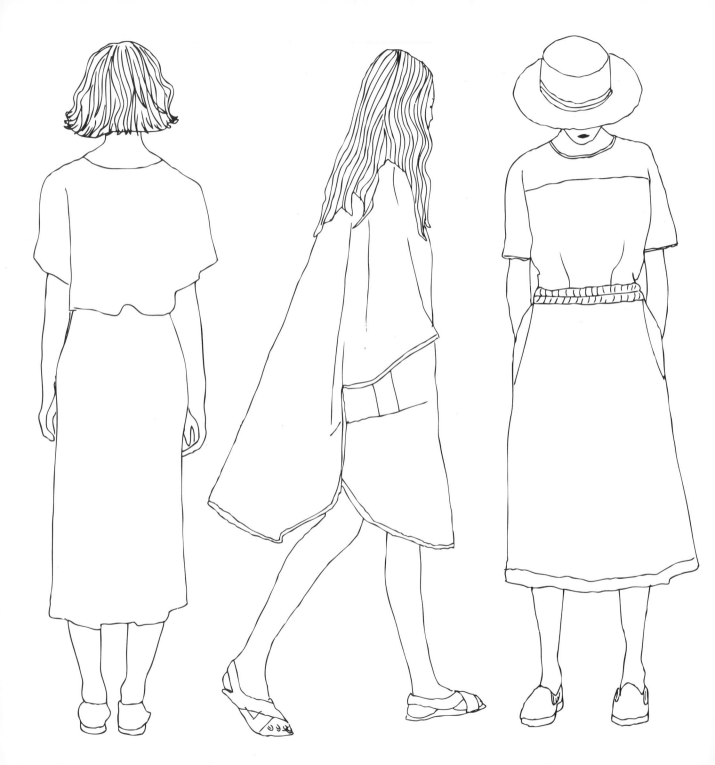

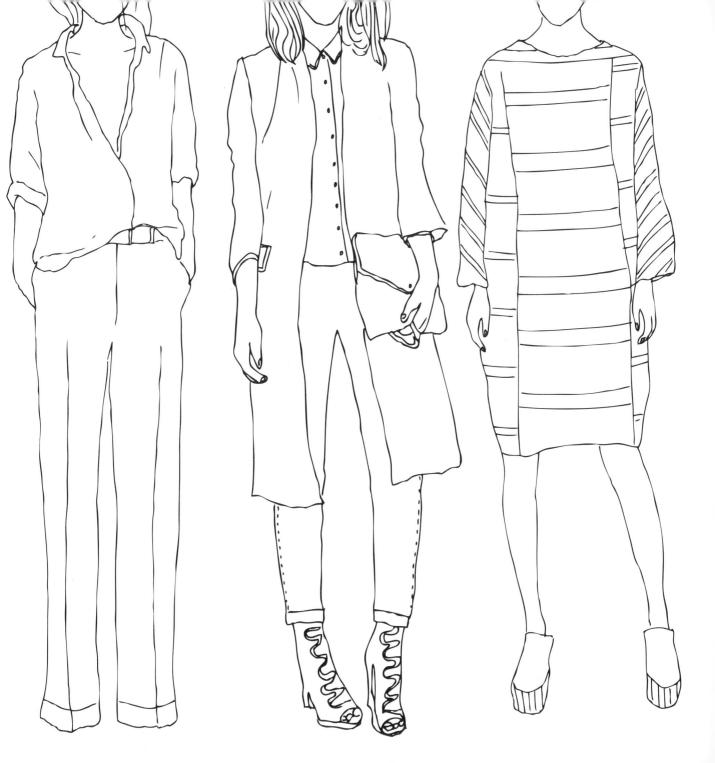

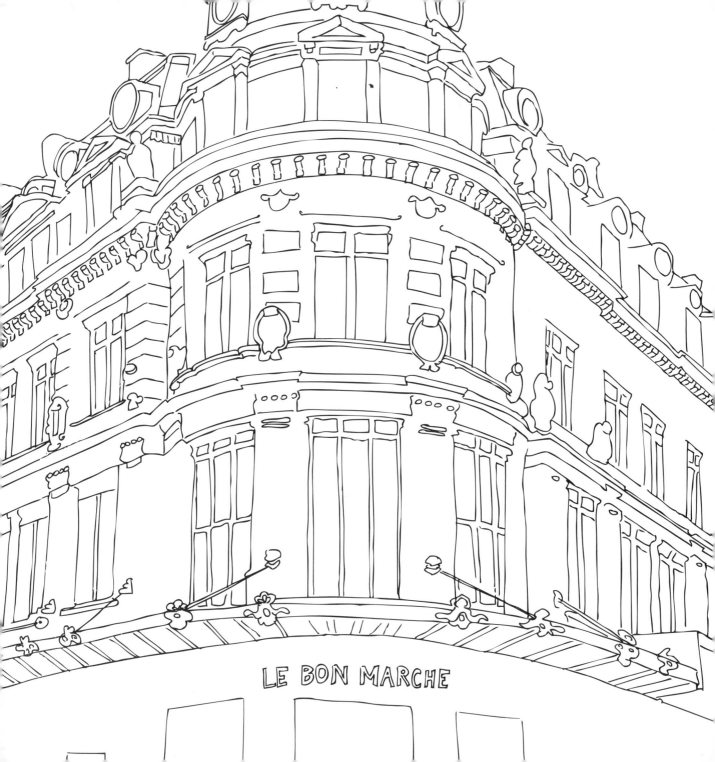

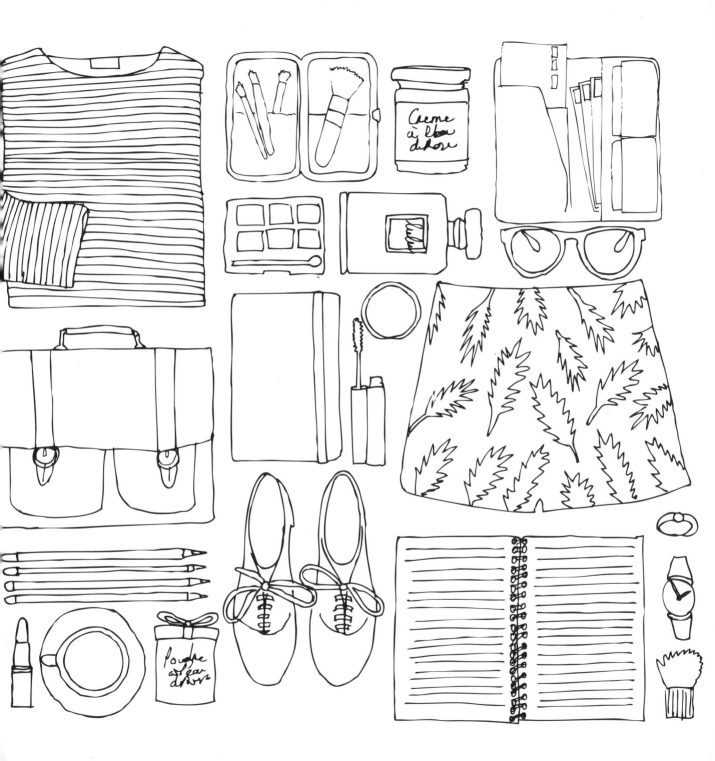

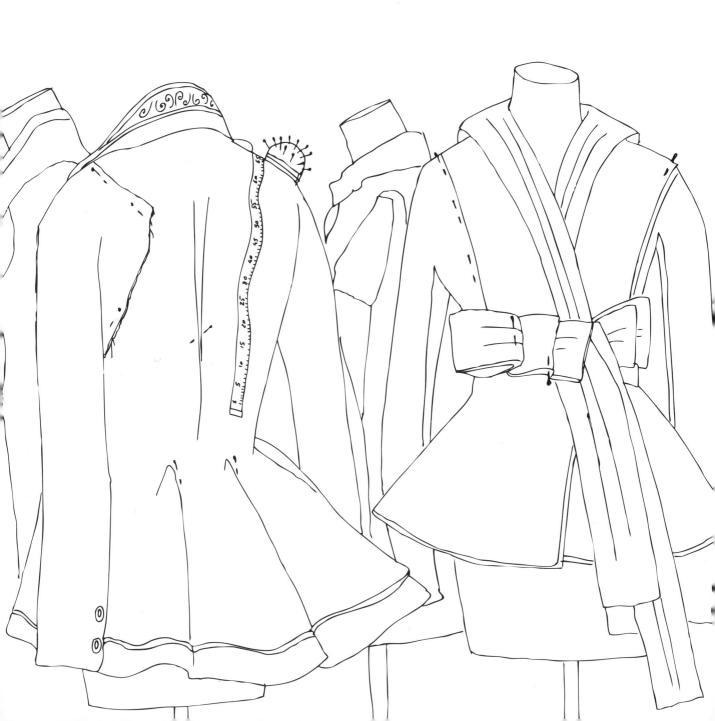

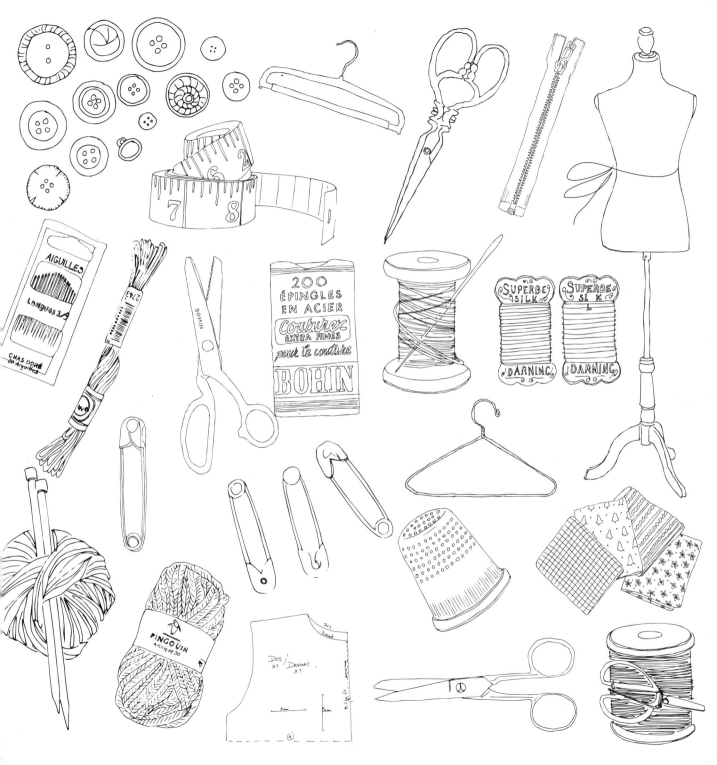

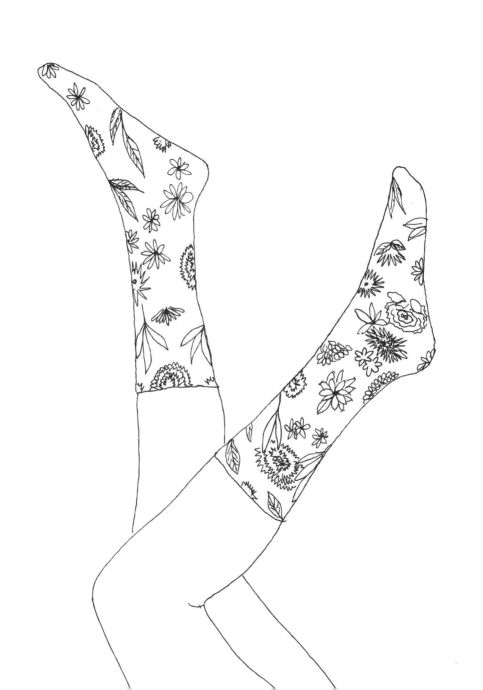

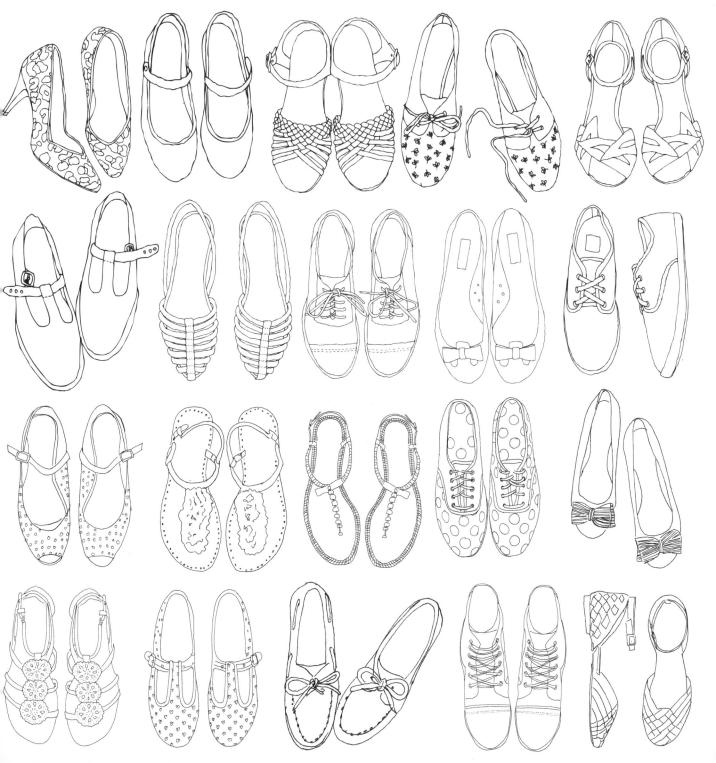

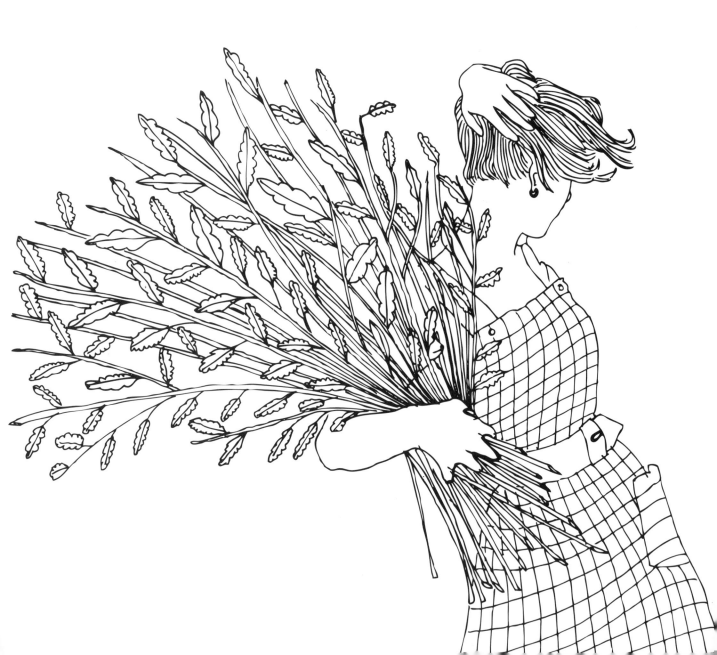

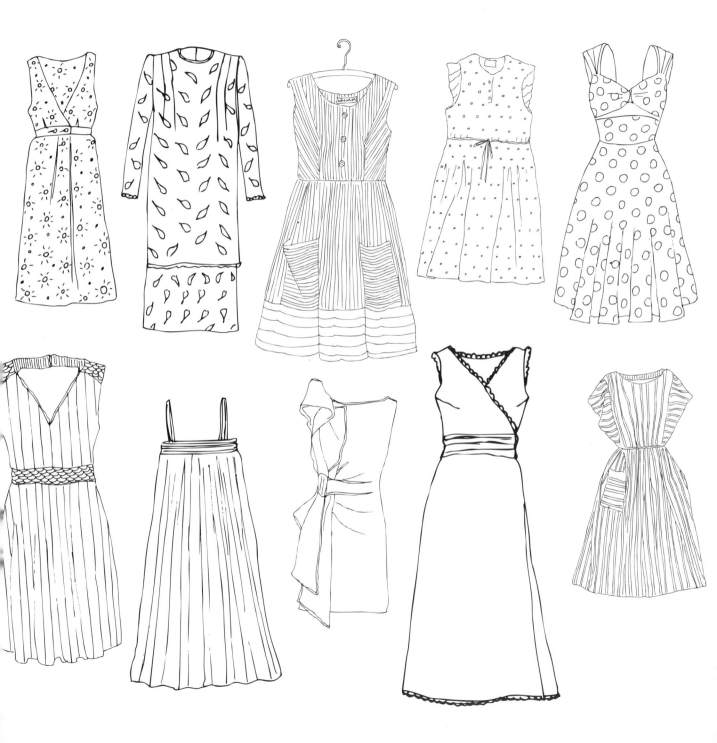

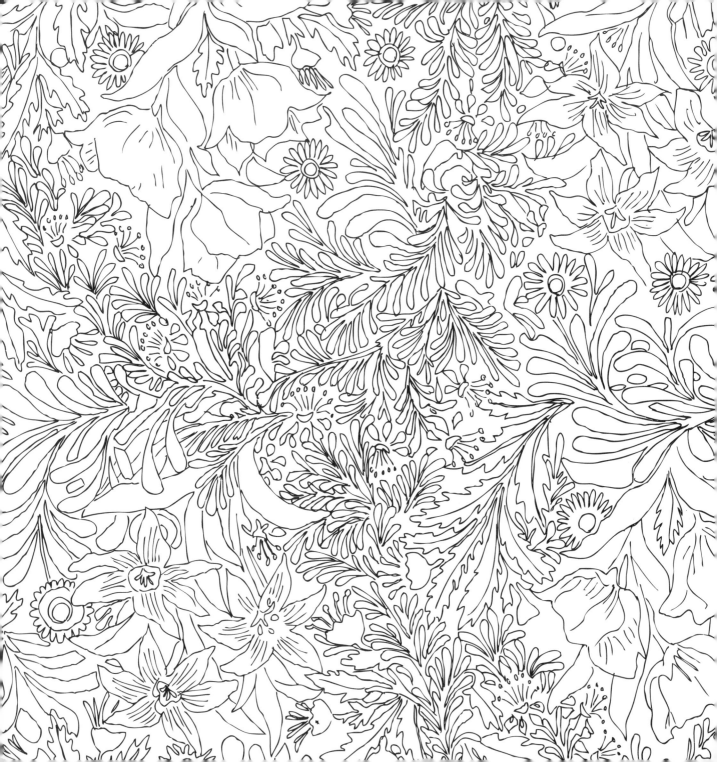

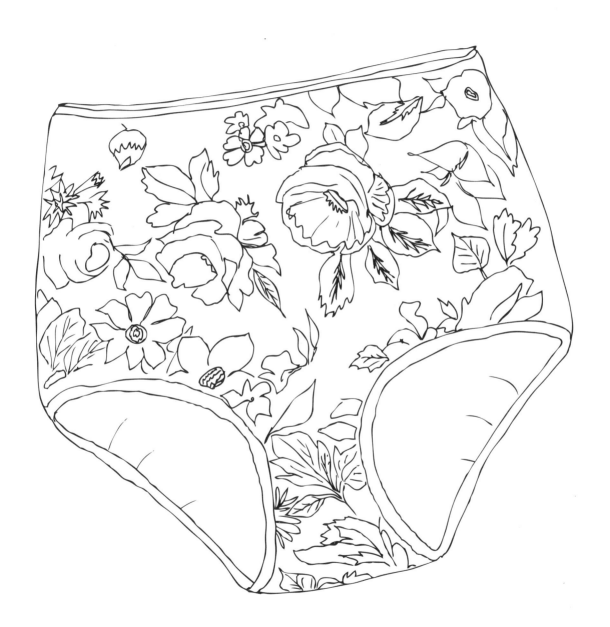

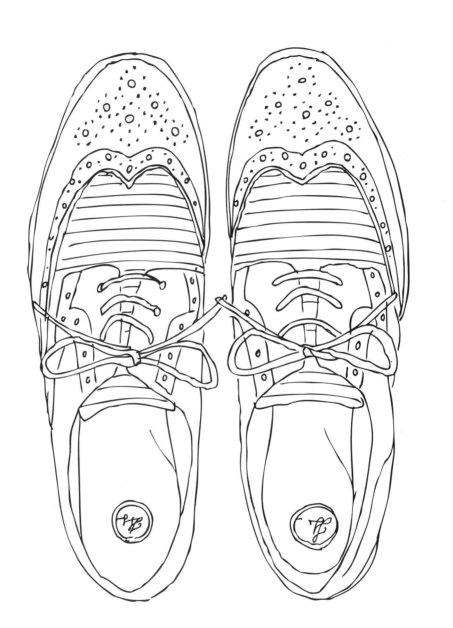

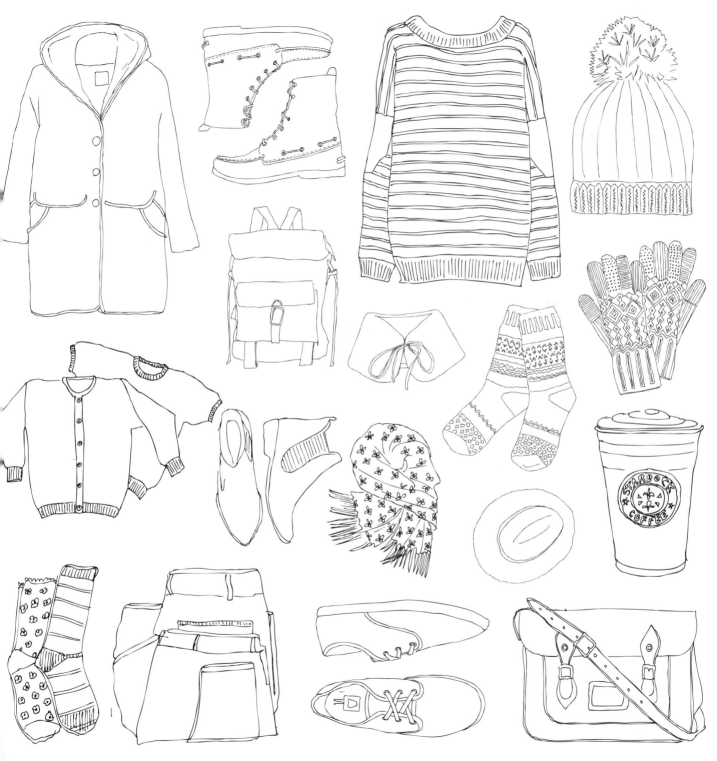

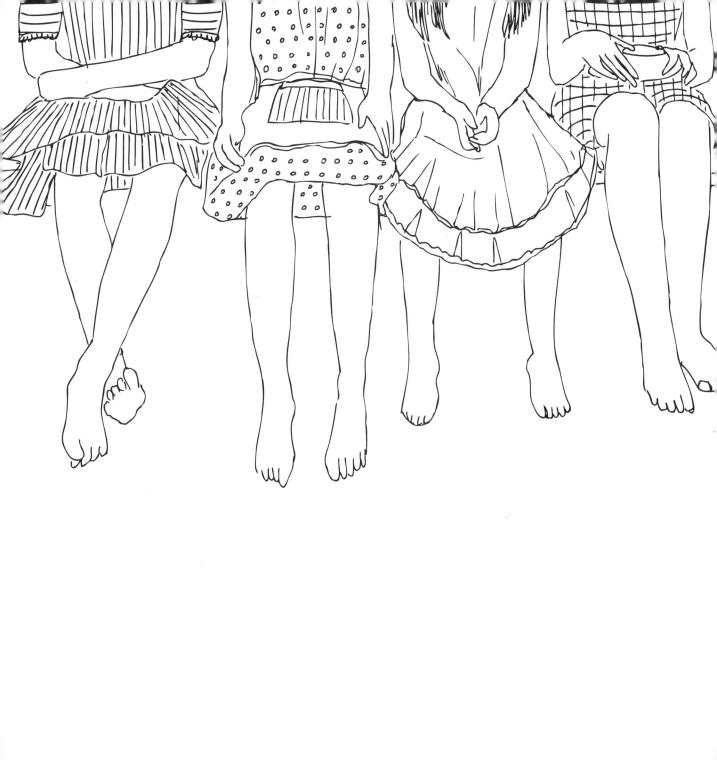

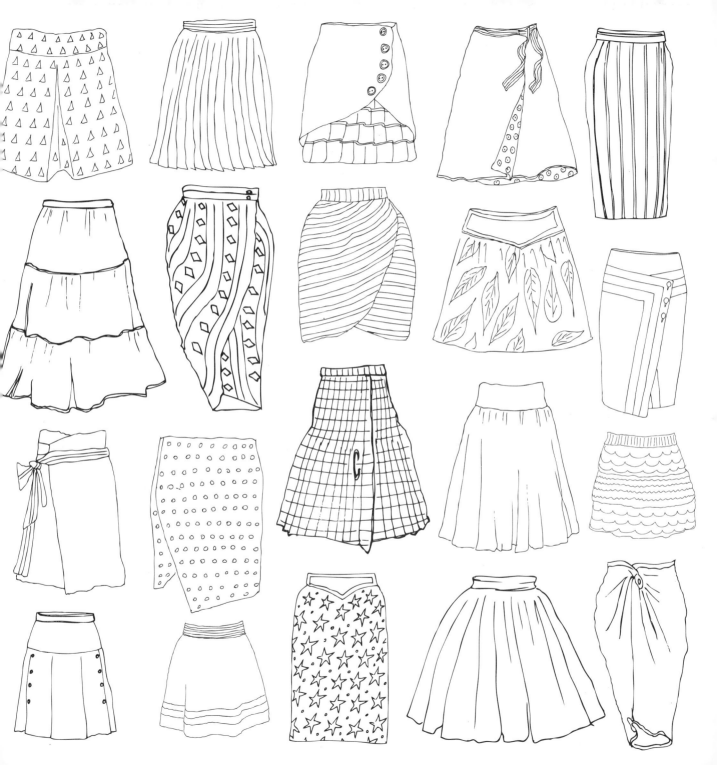

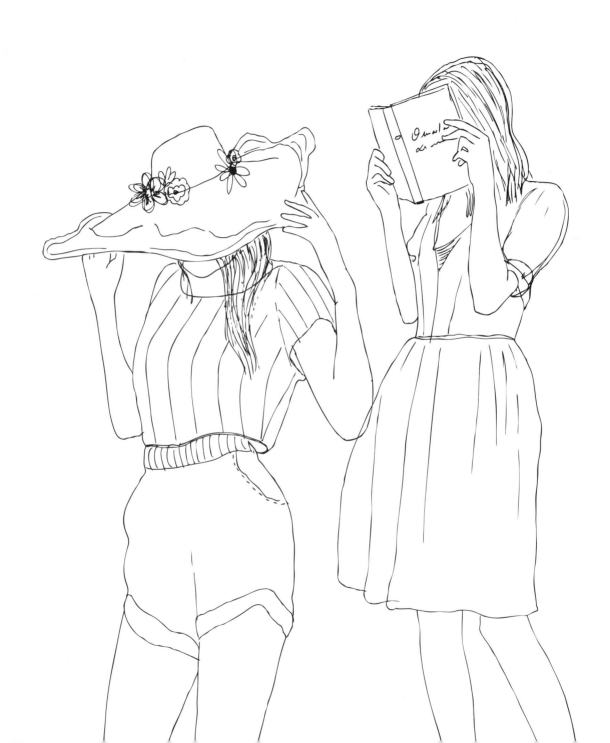

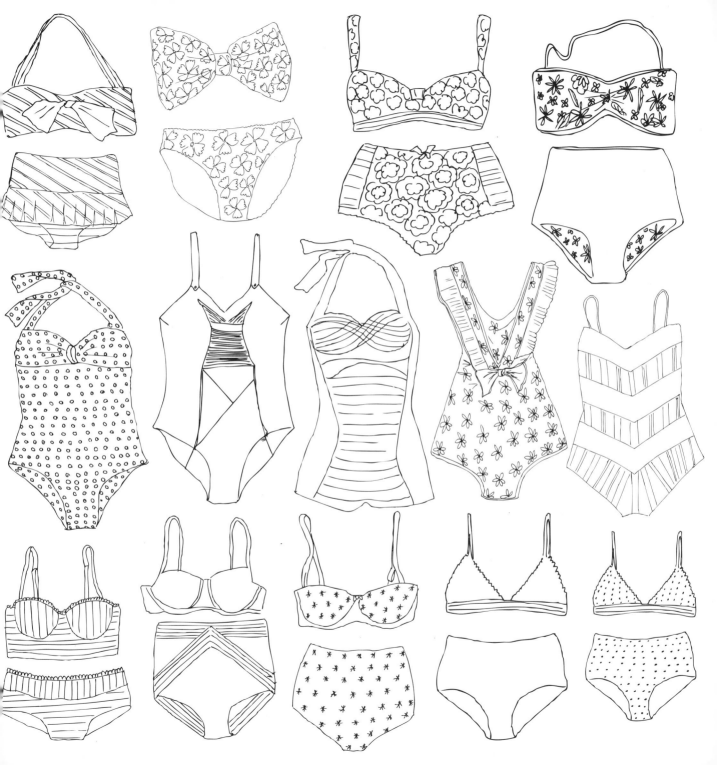

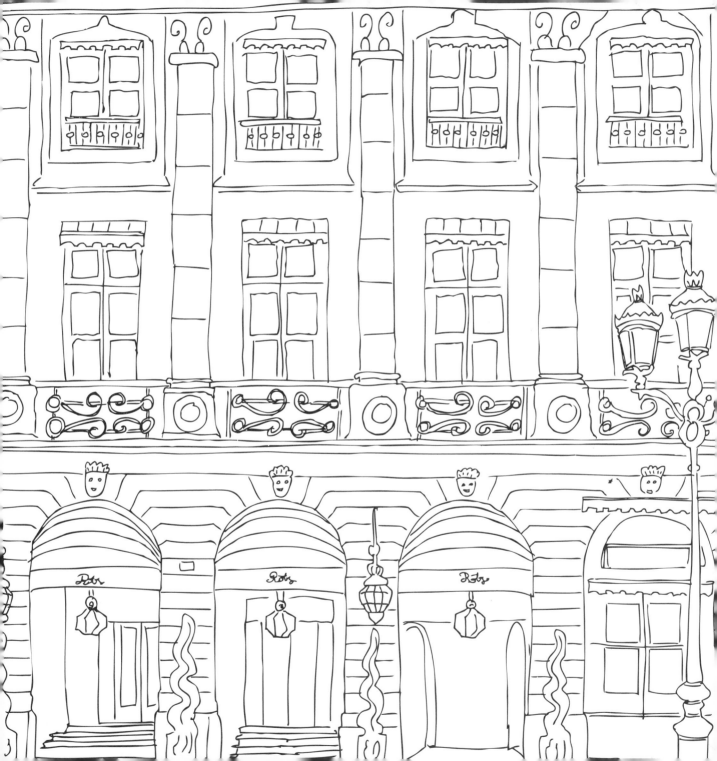

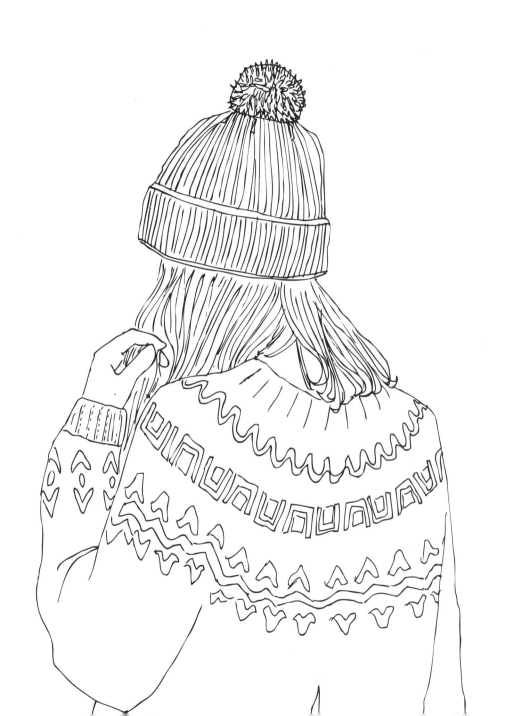

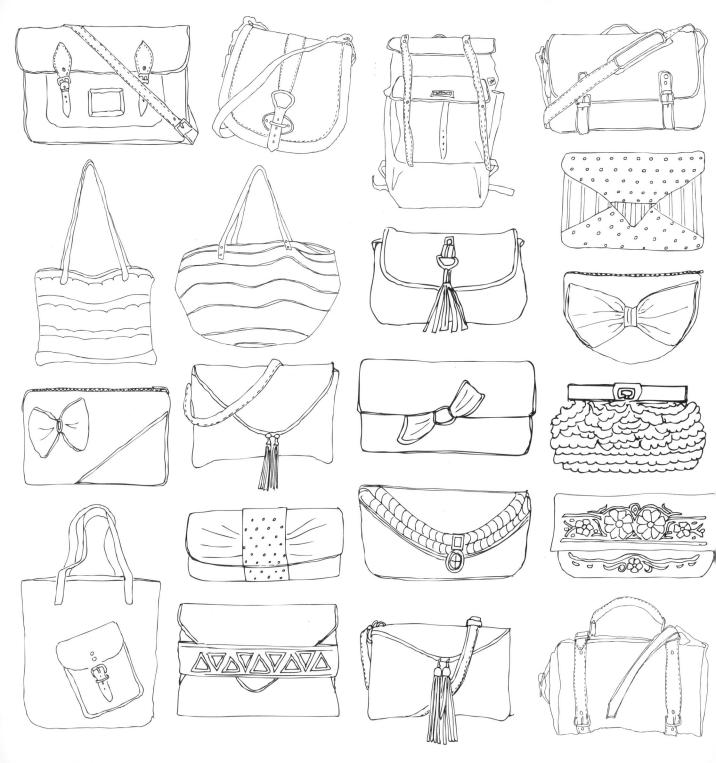

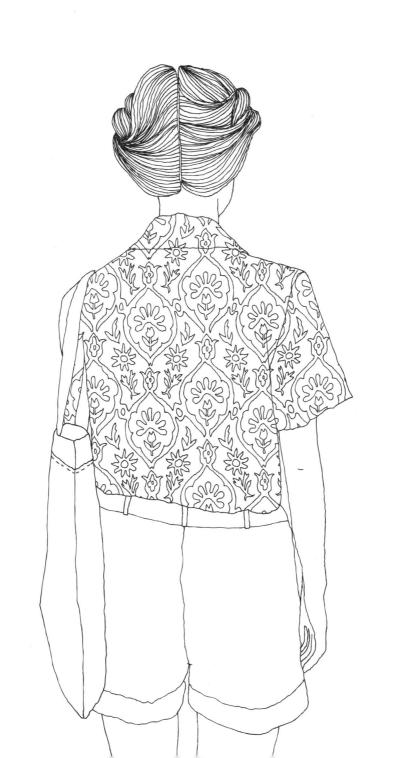

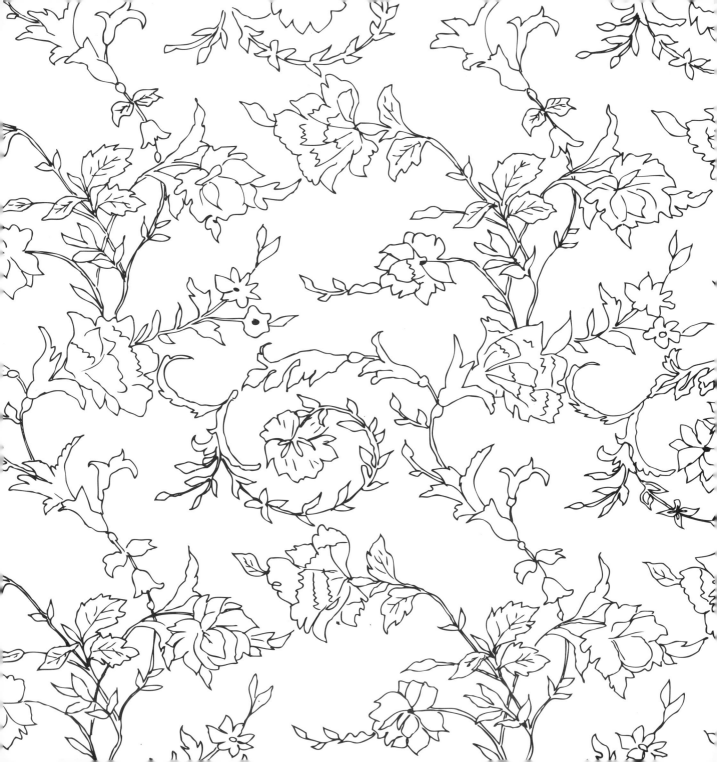

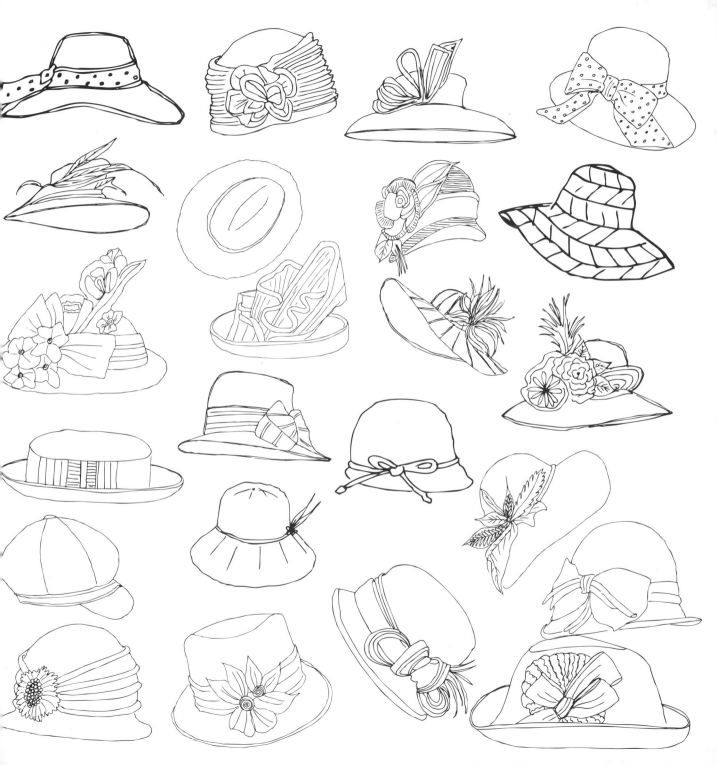

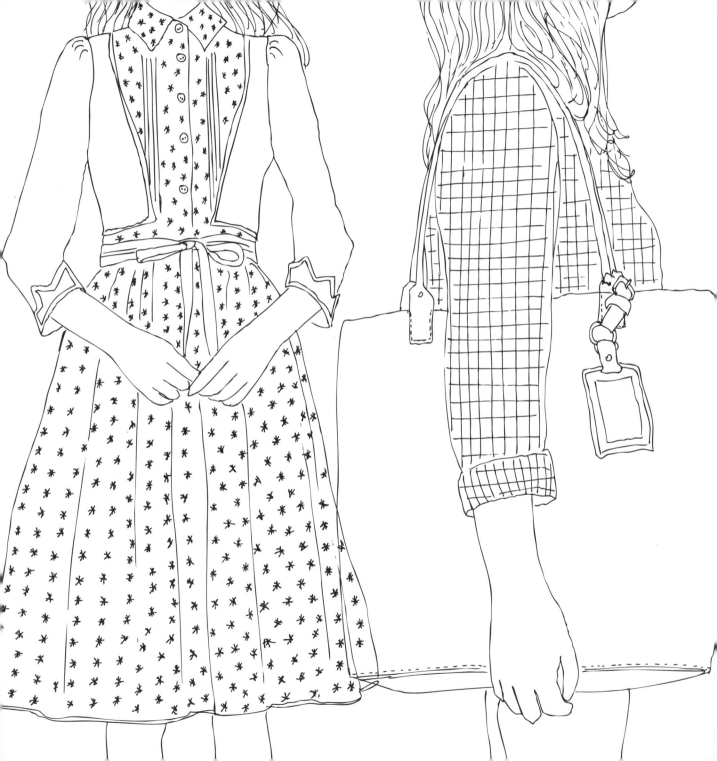

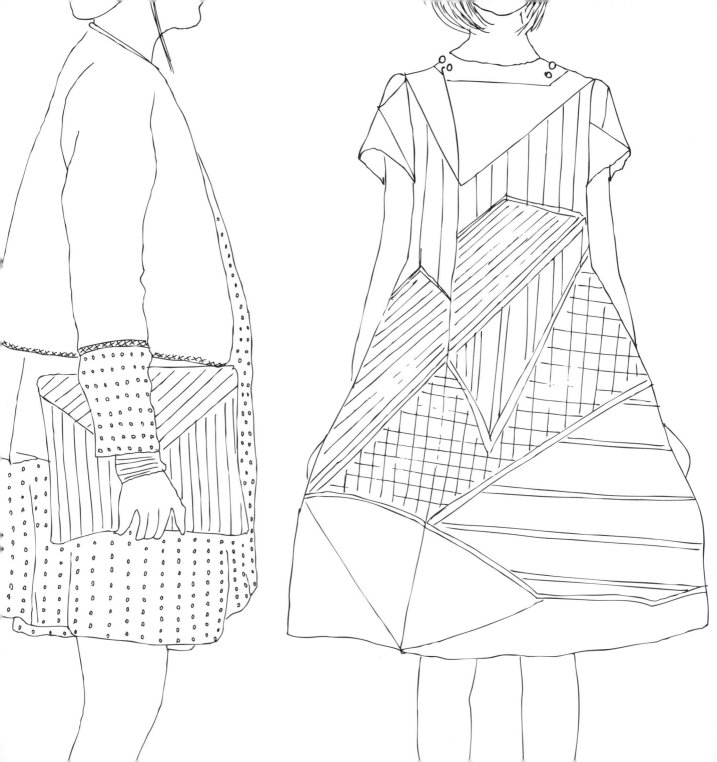

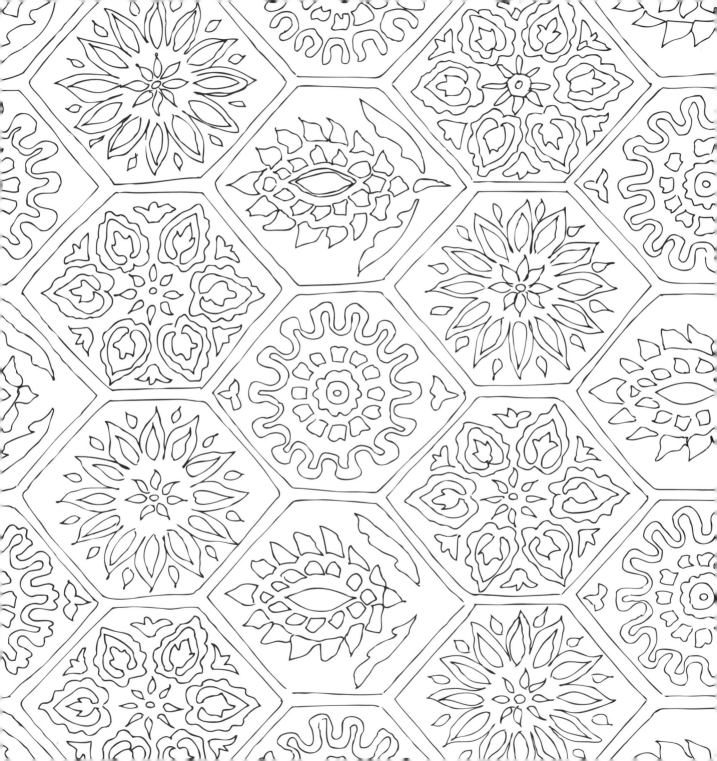

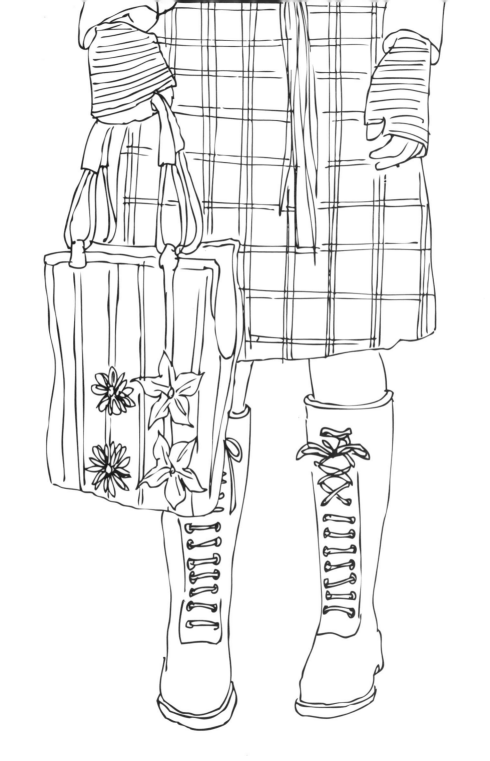

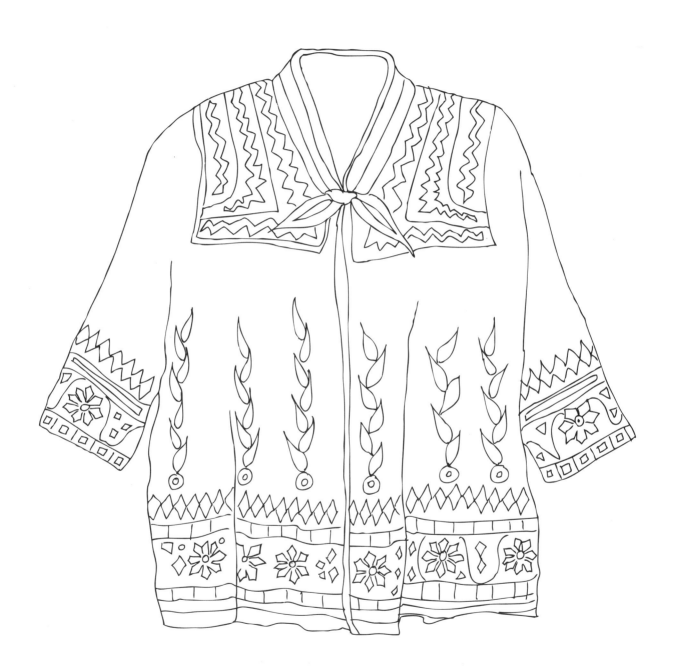

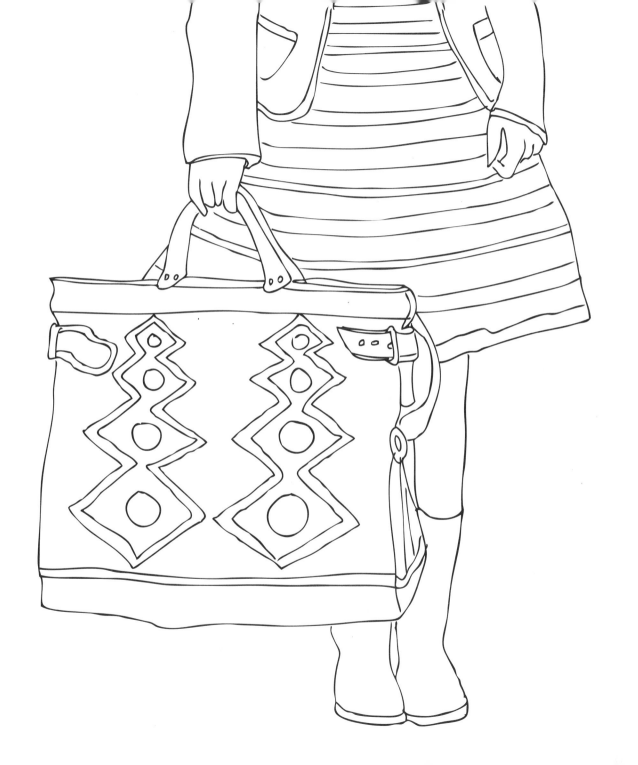

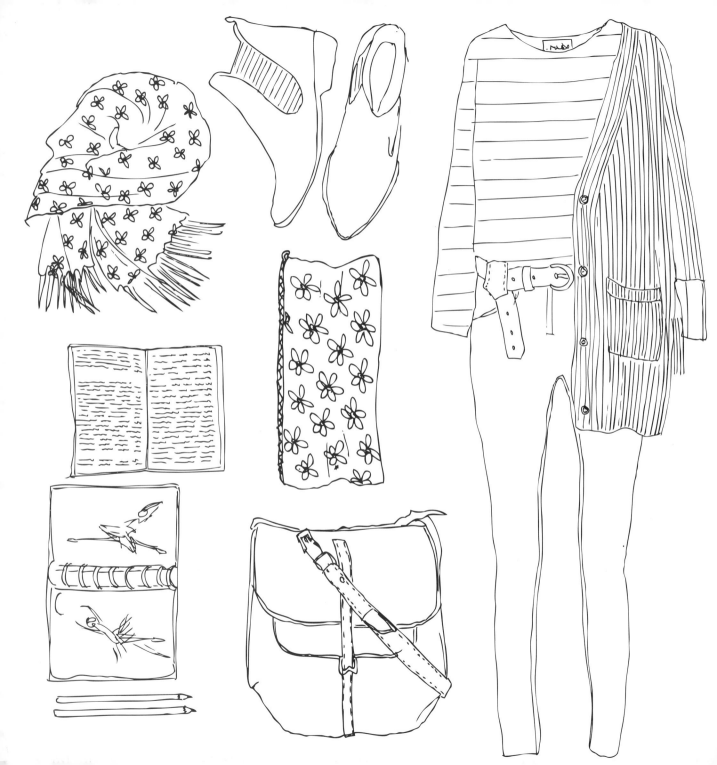

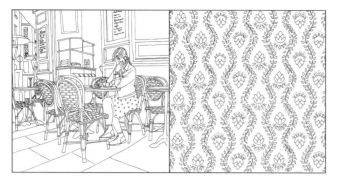

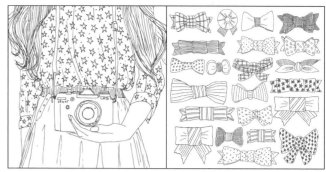

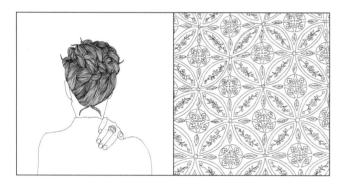

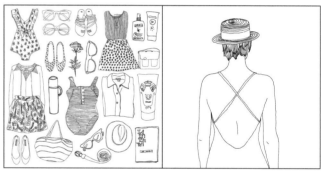

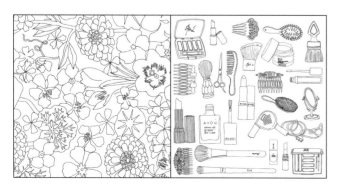

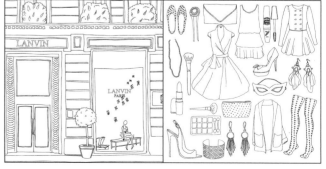

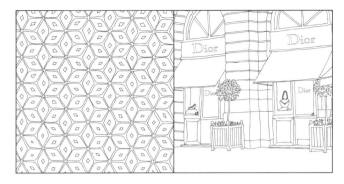

l'été indien

bonne nuit

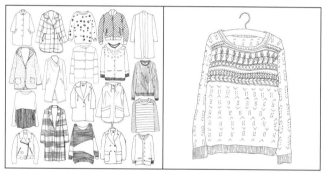

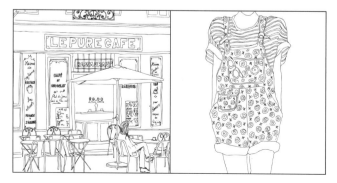

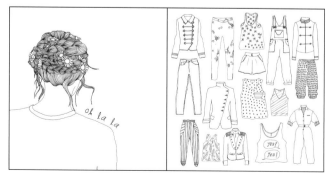

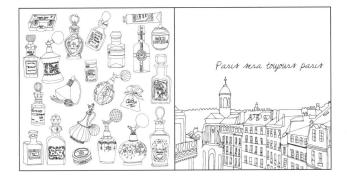

Paris sera toujours paris

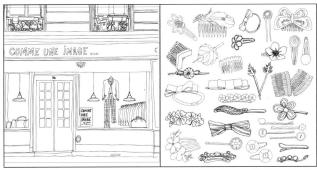

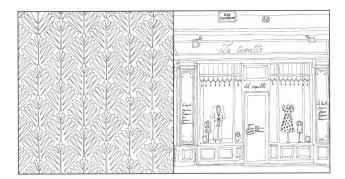

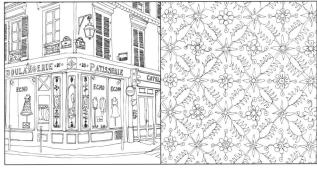

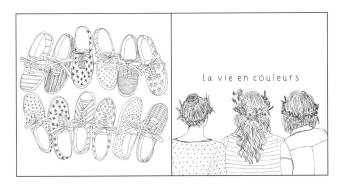

la vie en couleurs

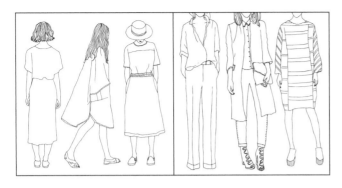

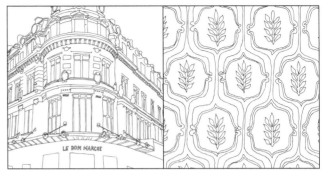

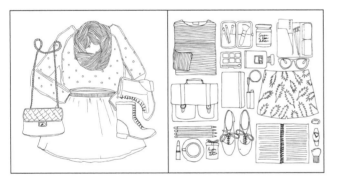

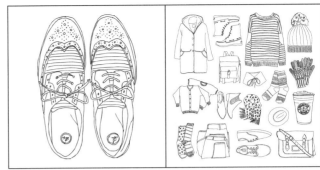
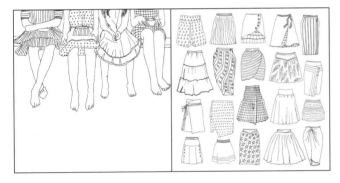
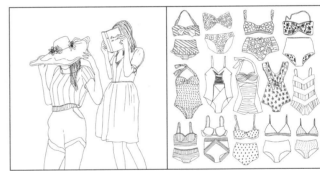
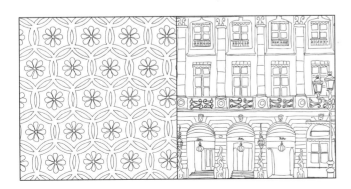